THE ESCAPIST'S

HarperCollins books may be purchased for educational, business,
or sales promotional use. For information please e-mail the
Special Markets Department at SPsales@harpercollins.com.

First published in 2016 by
Harper Design,
An Imprint of HarperCollins*Publishers*
195 Broadway
New York, NY 10007
Tel: (212) 207-7000
Fax: (855) 746-6023
harperdesign@harpercollins.com
www.hc.com

This edition distributed throughout North America by:
HarperCollins*Publishers*
195 Broadway
New York, NY 10007

ISBN 978-0-06-257365-0

First Printing, 2016

Printed and bound in China

THE ESCAPIST'S

DOT TO DOT

EXTRAORDINARY PLACES

Connect the dots. Unveil a masterpiece.

HARPER
DESIGN

An Imprint of HarperCollinsPublishers

HOW TO USE
THIS BOOK

Dot-to-dots were a requisite of childhood; a simple puzzle that kept us quiet for a few moments while we excitedly uncovered the scenes within them. It is this philosophy that runs throughout the Escapist series, with each image offering a short sojourn from the stresses of your day, allowing you to slow everything down and lose yourself in those few moments when your focus is devoted solely to satisfyingly watching a picture take form through the lines you draw.

Each puzzle within this book will take 10 to 20 minutes to complete, and needs nothing more than your pen or pencil of choice to get going. Here are some extra tips and ideas to think about along the way:

- Look for the triangle (▲) to start.

- Opt for a thin pen over thick, such as a fine felt tip, and choose one that doesn't smudge easily.

- If you can't find the next number, try not to rush ahead. Look farther afield to the left, right, up and down.

- Don't worry about making mistakes; extra lines add texture!

- Experiment with your creations. Why not use a colored pencil to connect the dots, add shading or color in the pictures once finished?

- For a printable key with all of the completed illustrations, please visit hc.com/placeskey.

However you choose to bring your images to life, we hope they prove a satisfying and creative time-out from your day. Enjoy!

●●●

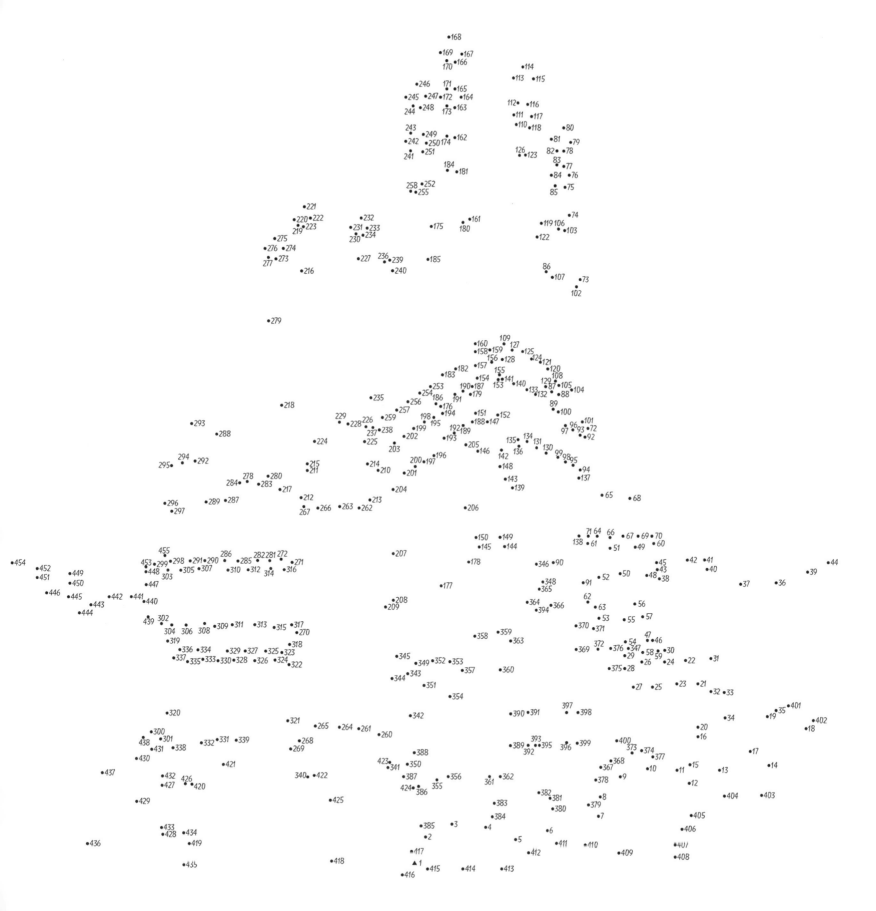

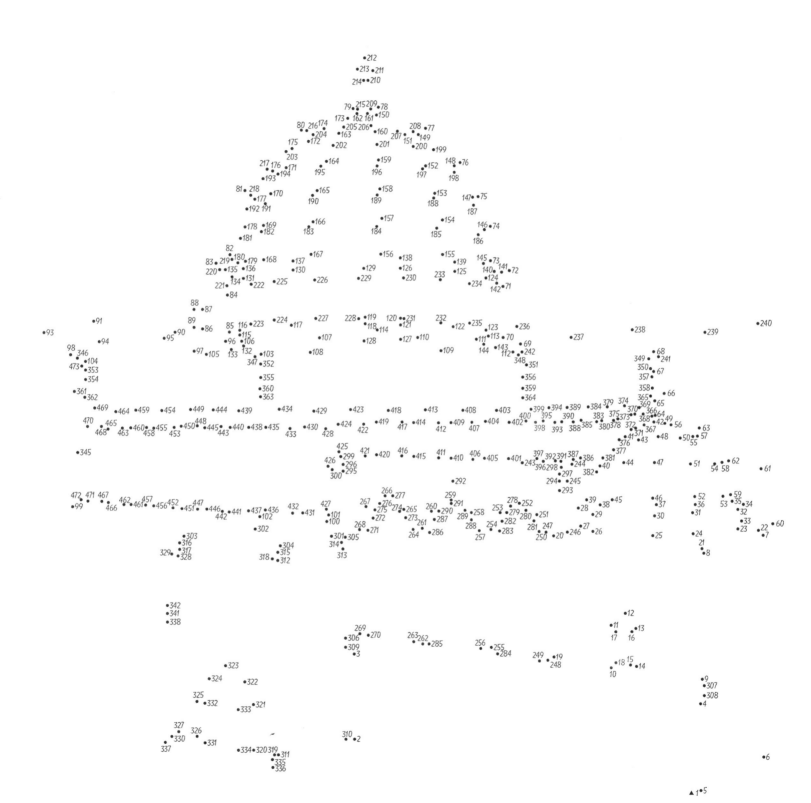

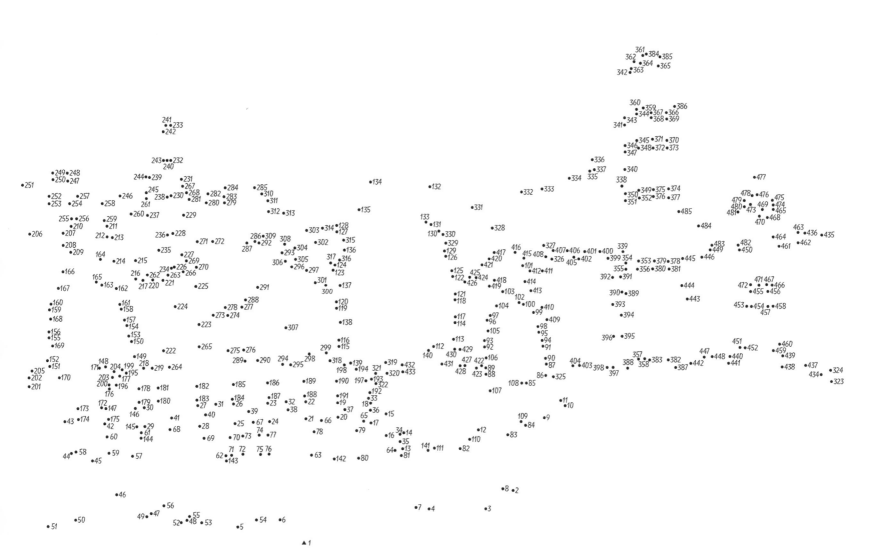

▲ 1

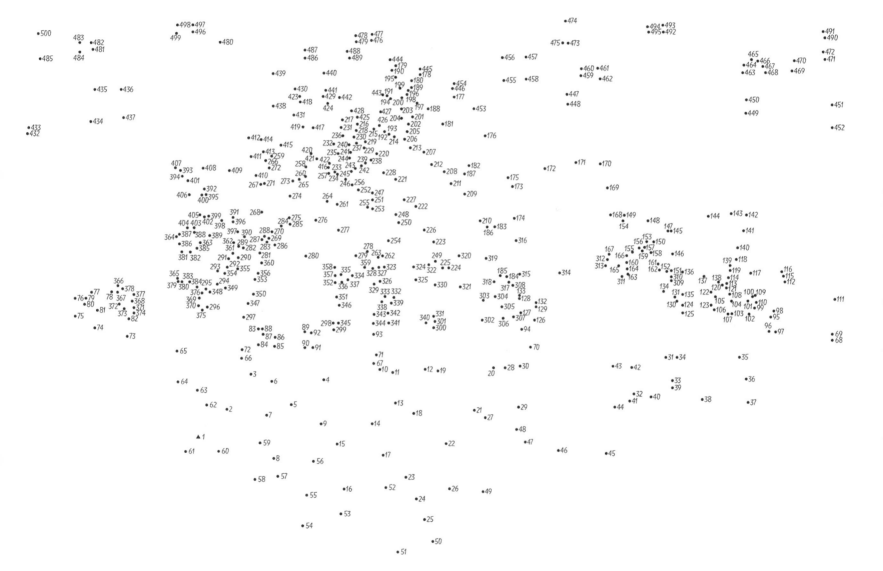

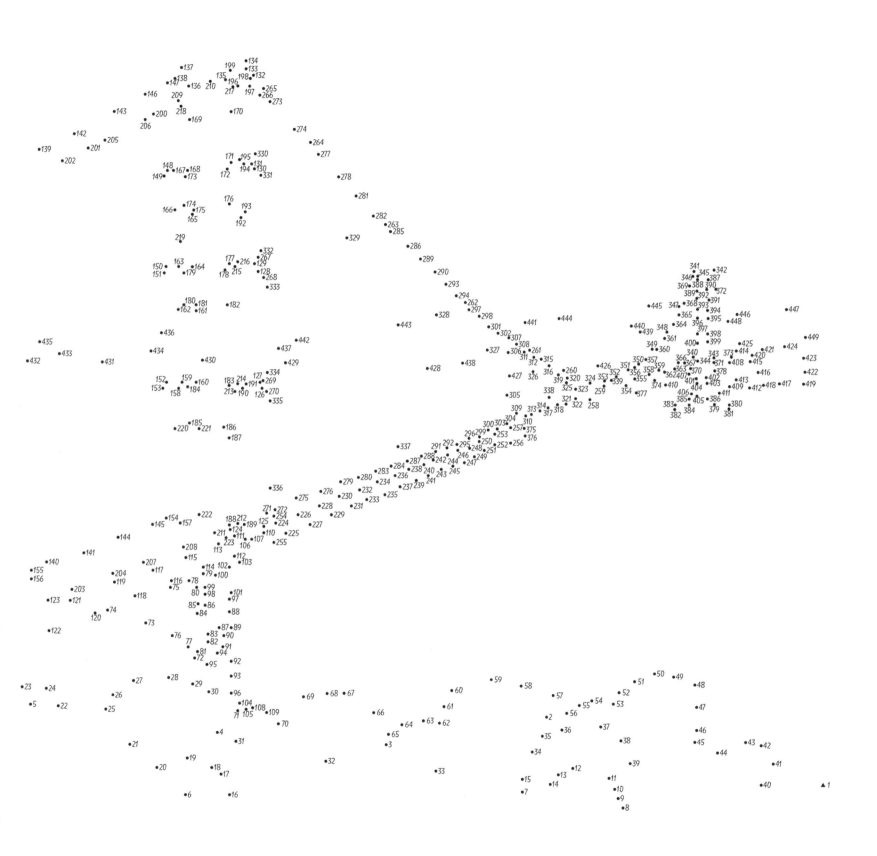

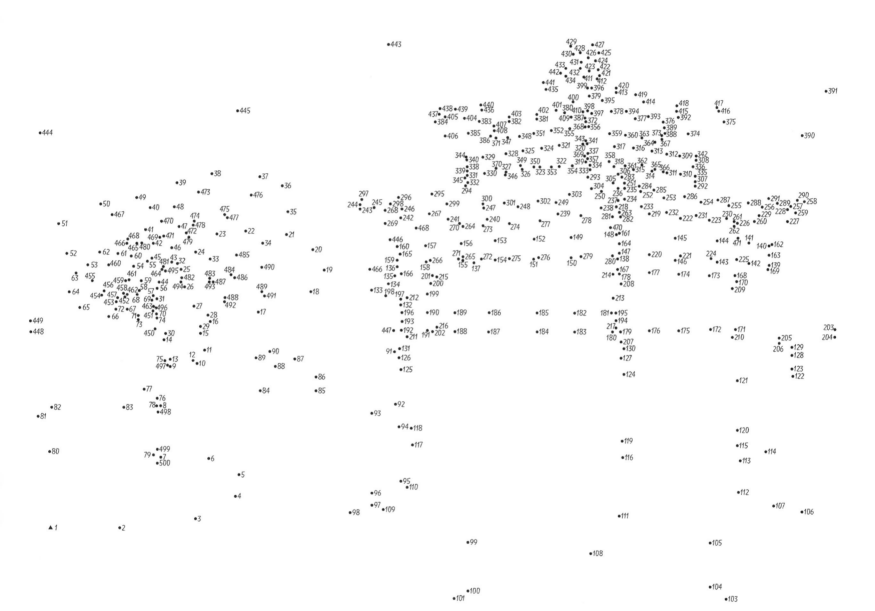

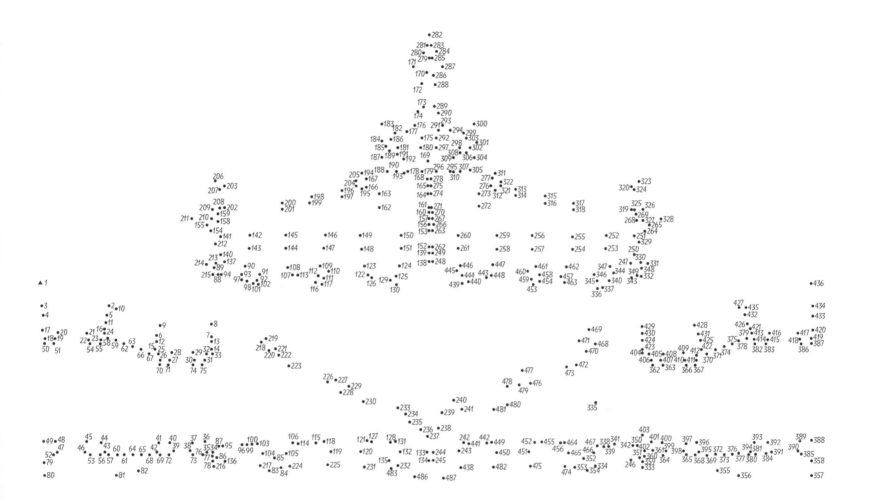

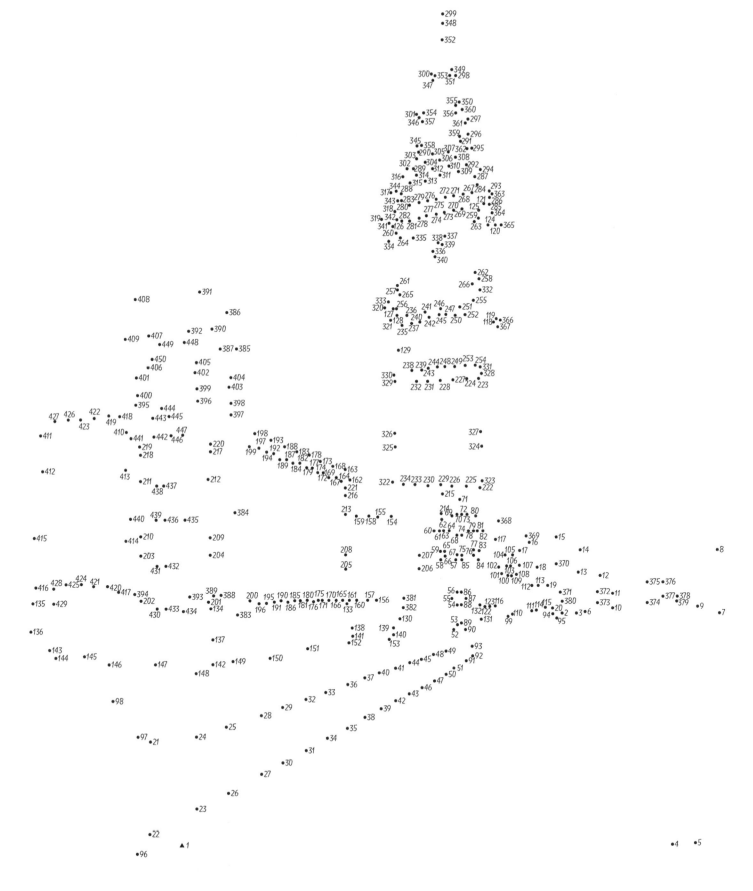

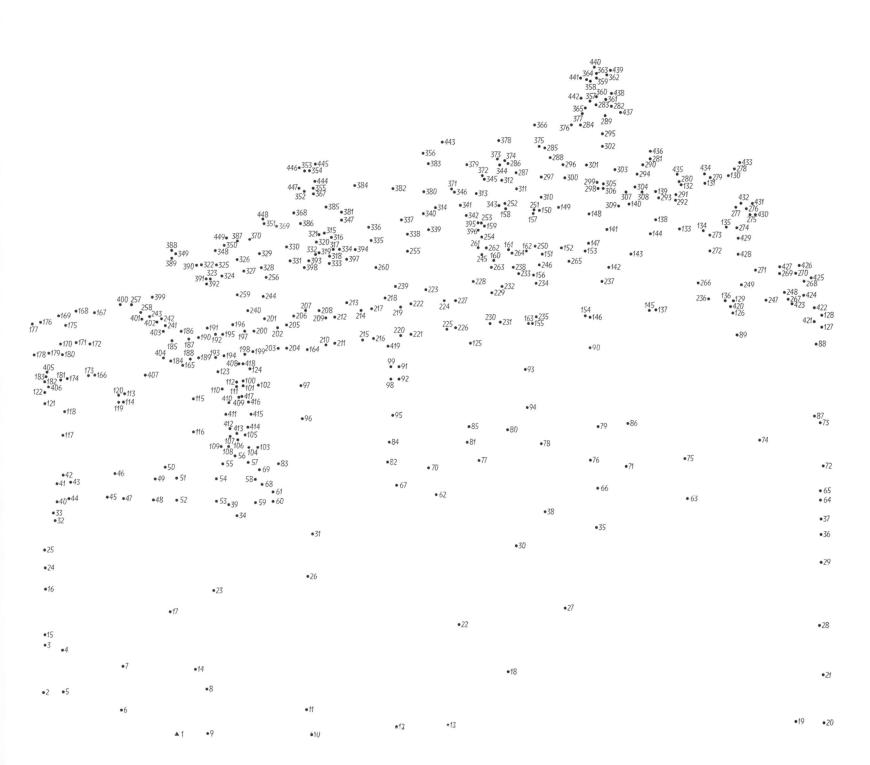

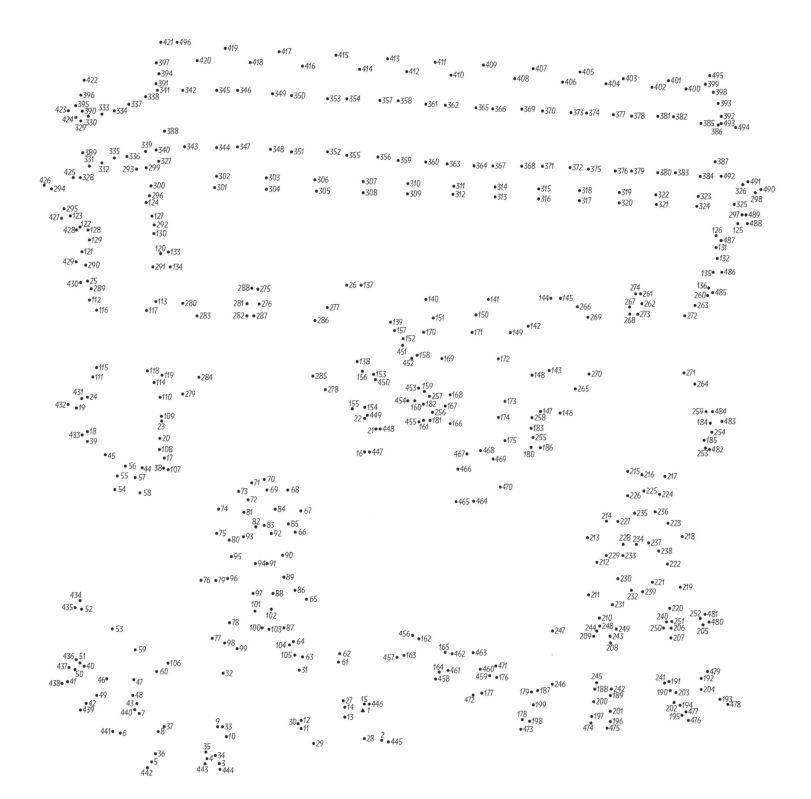

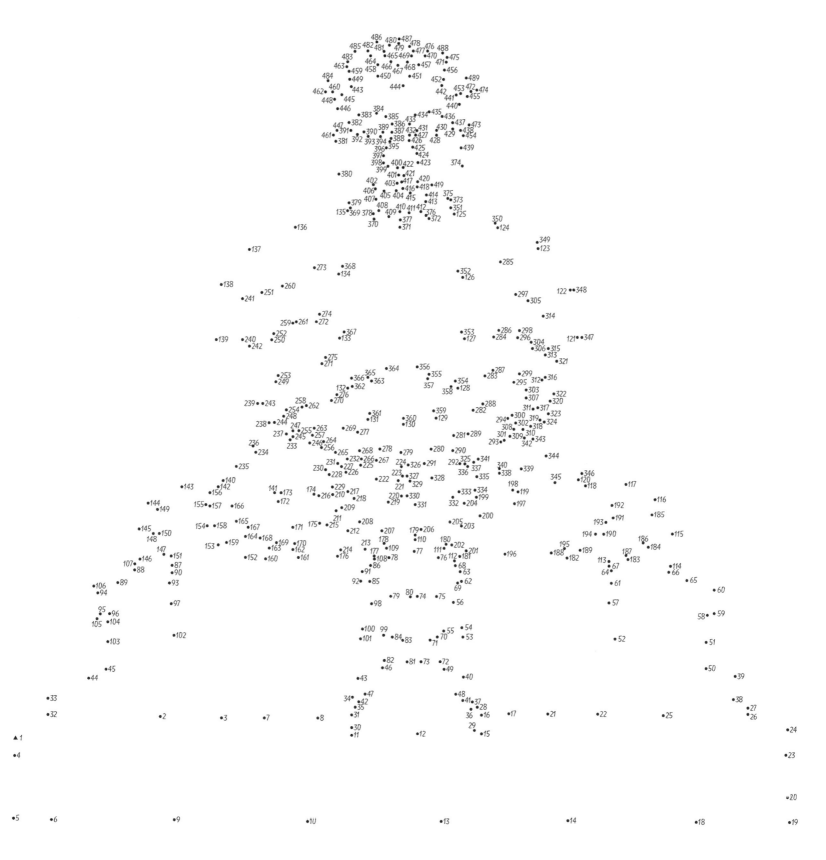

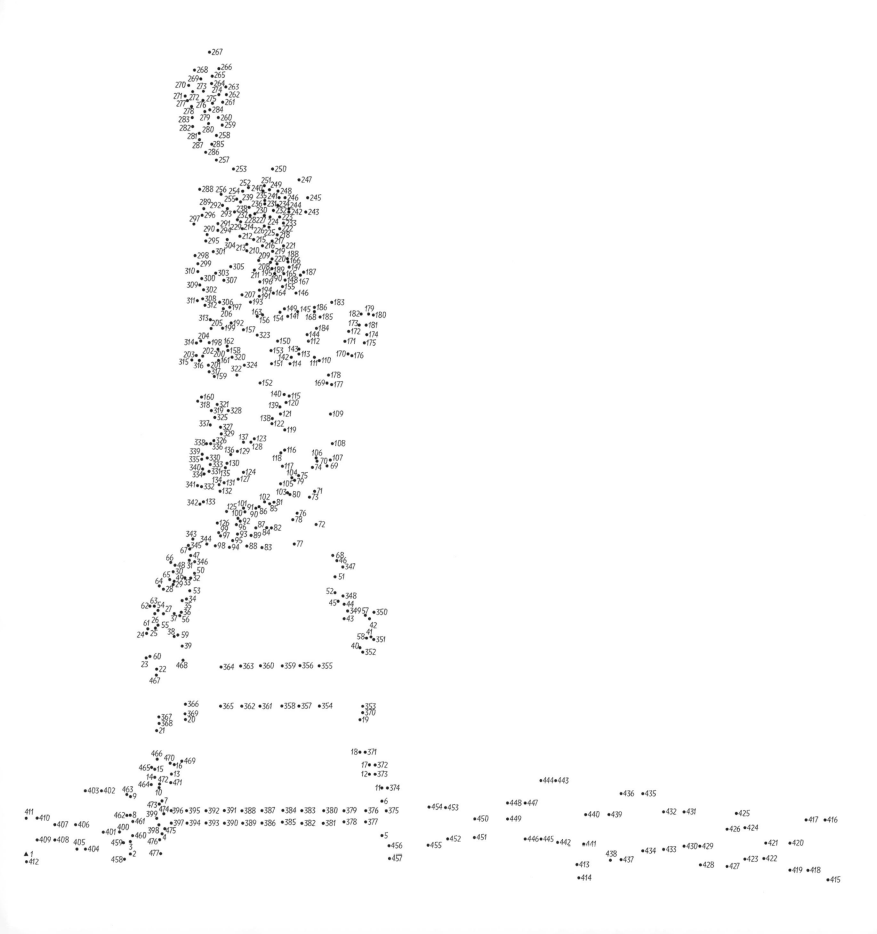

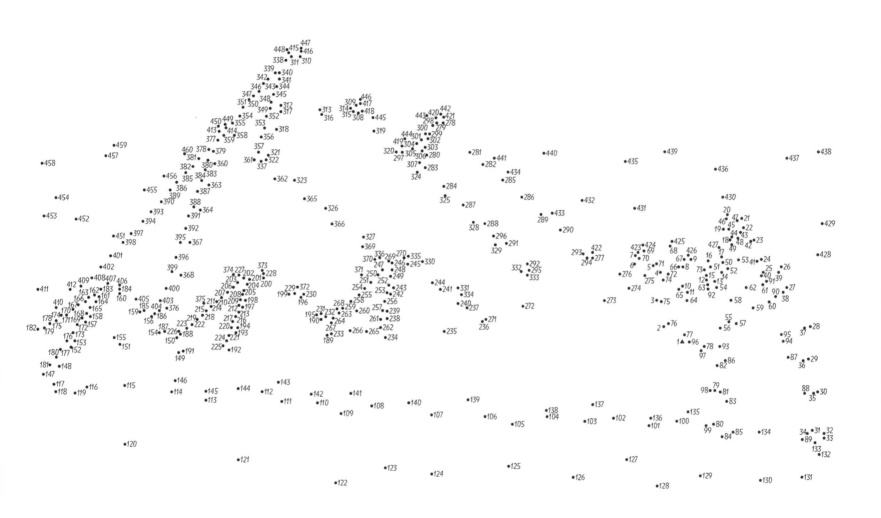

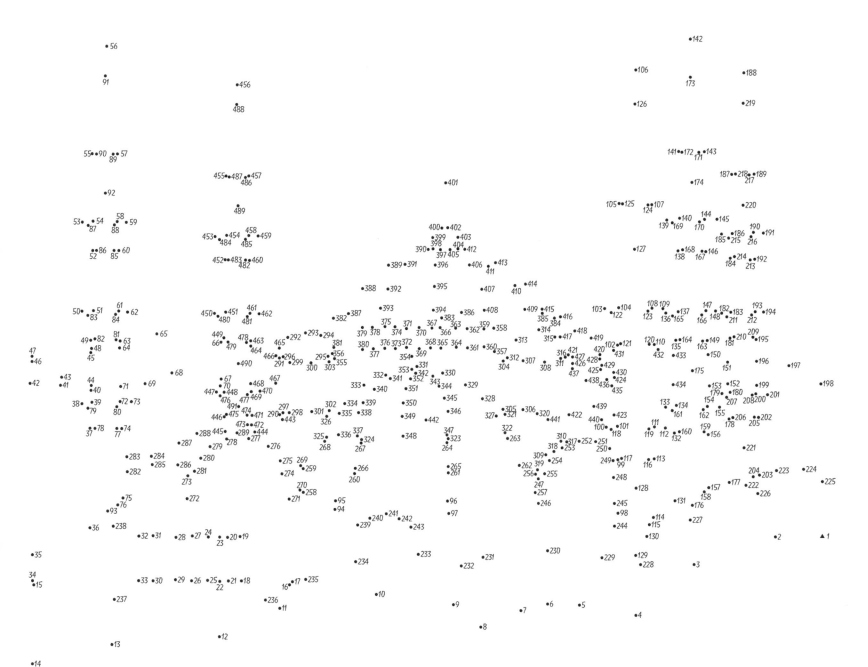

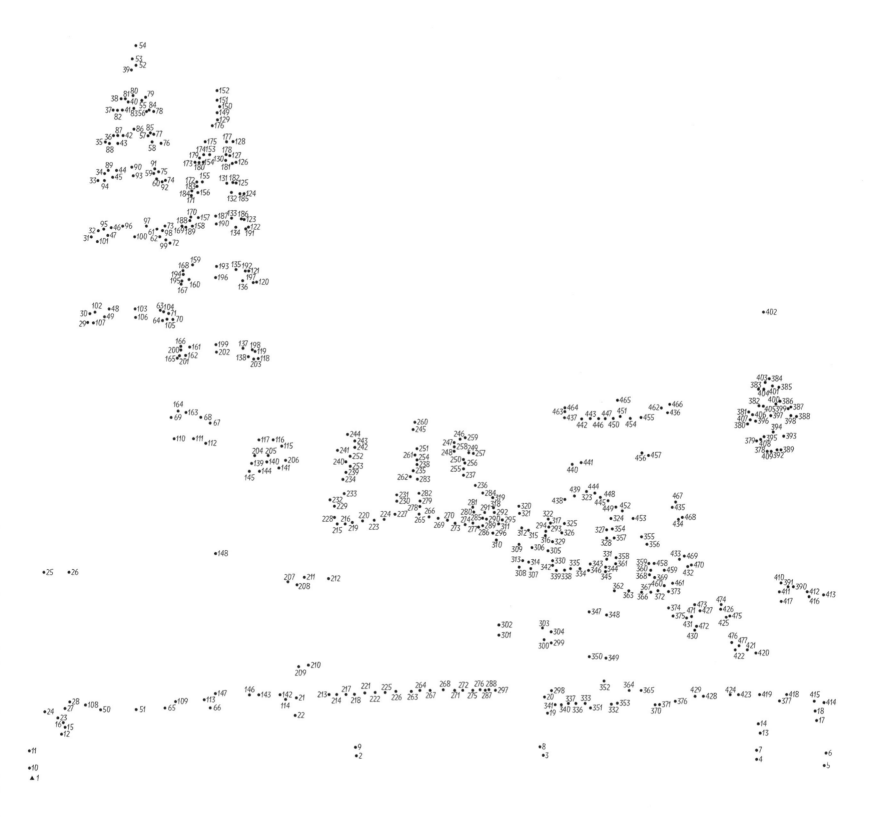

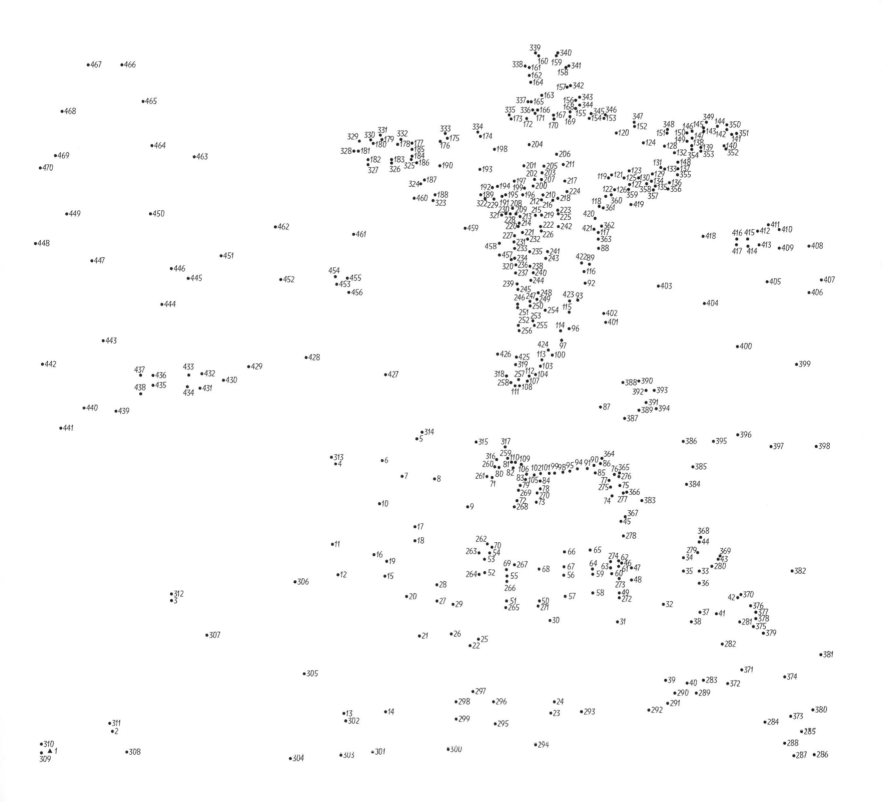

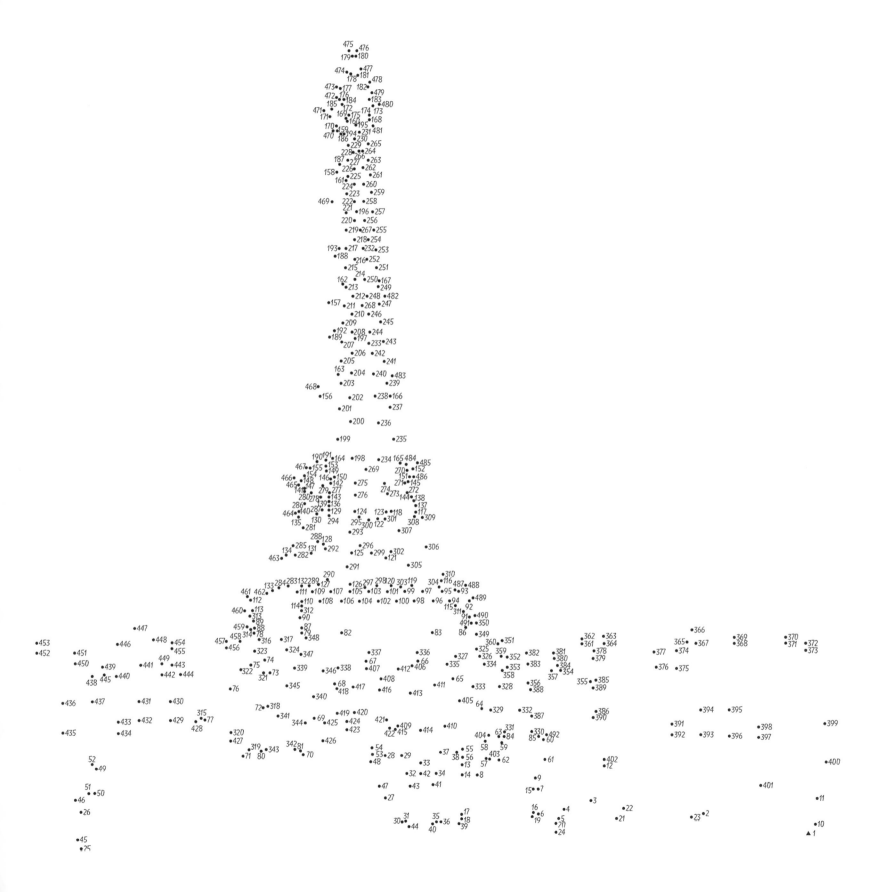

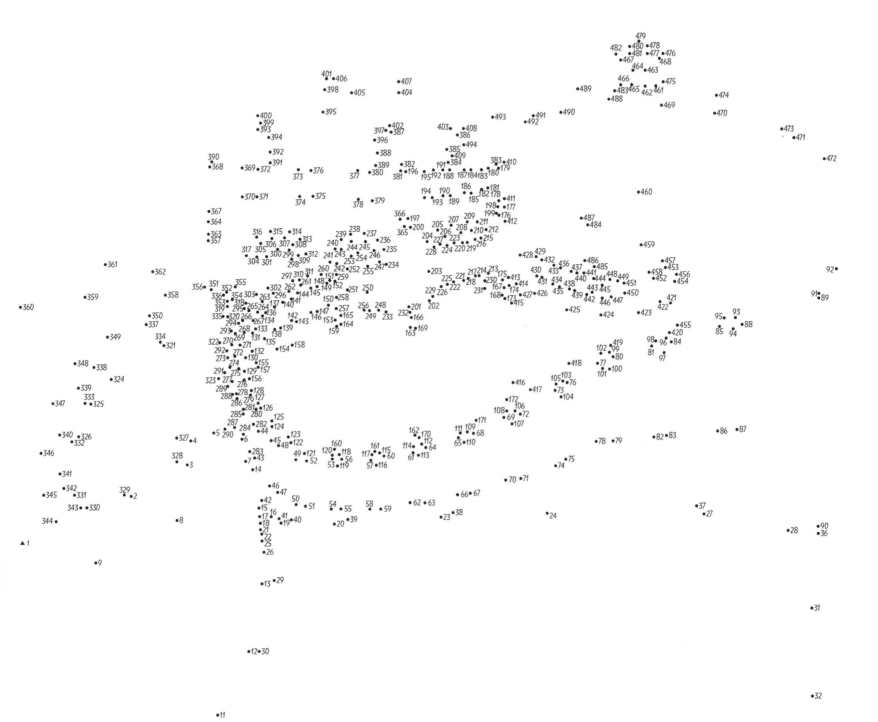

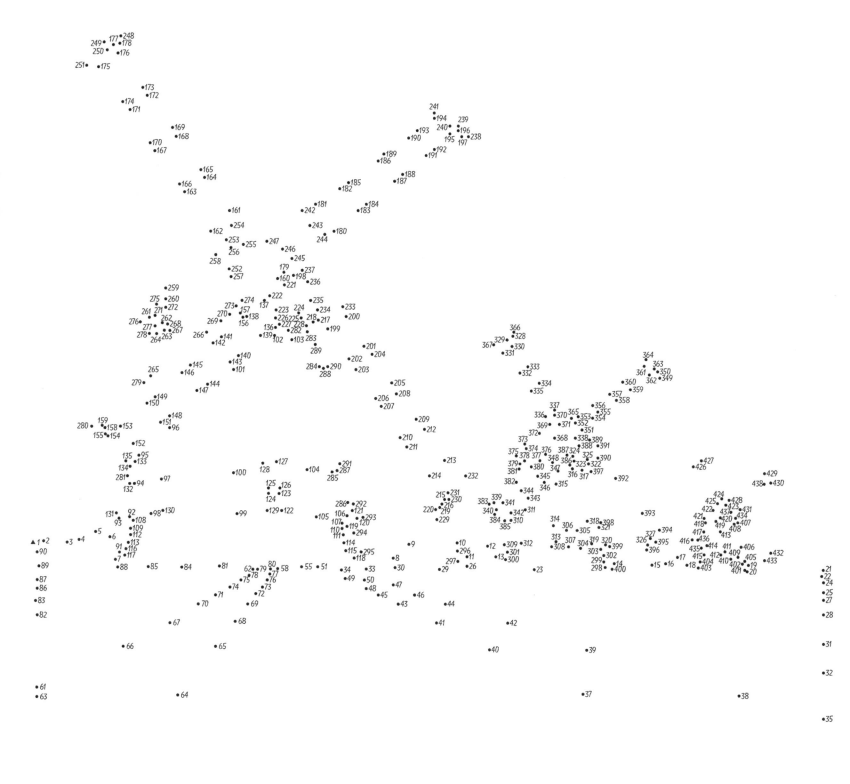

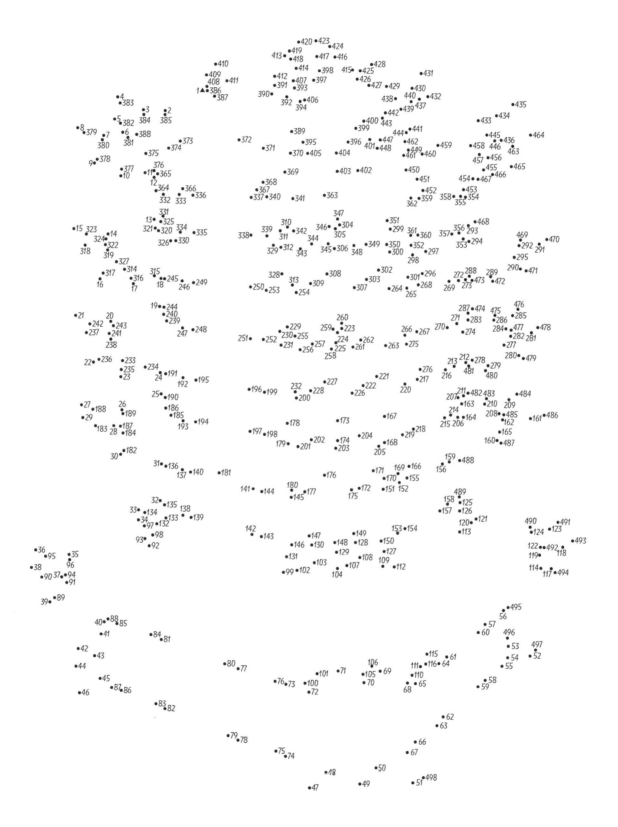

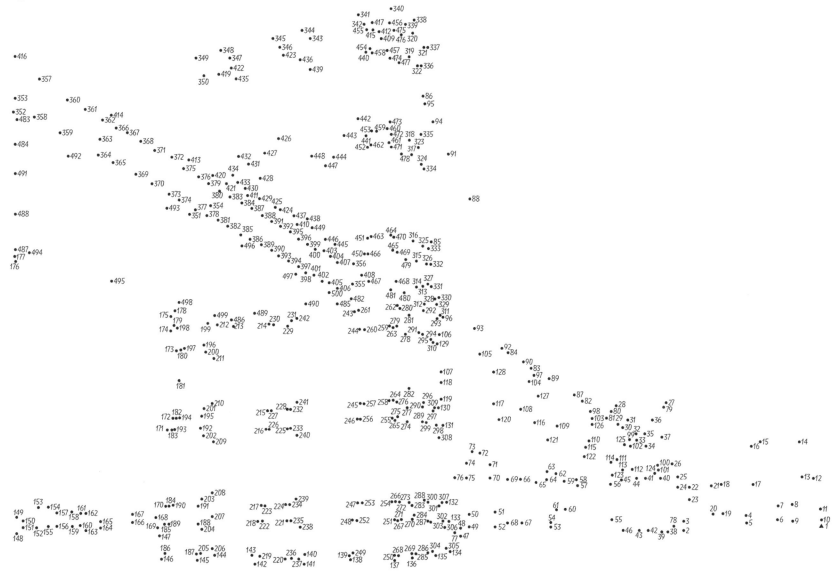

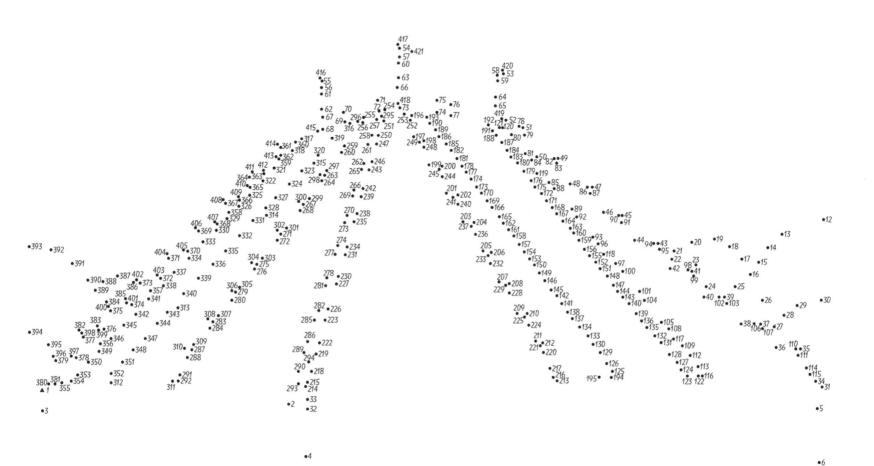

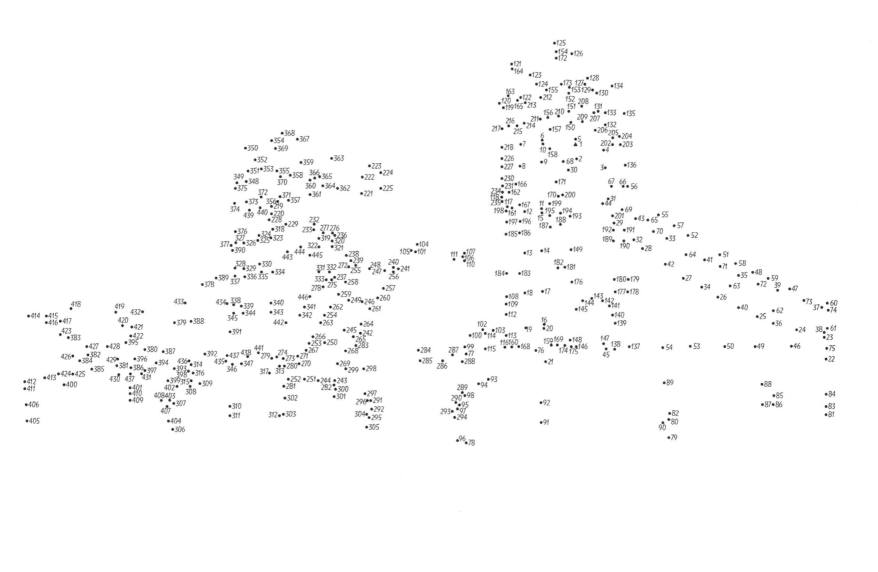

This is a connect-the-dots puzzle page consisting of numbered dots (1 through 451) to be connected.

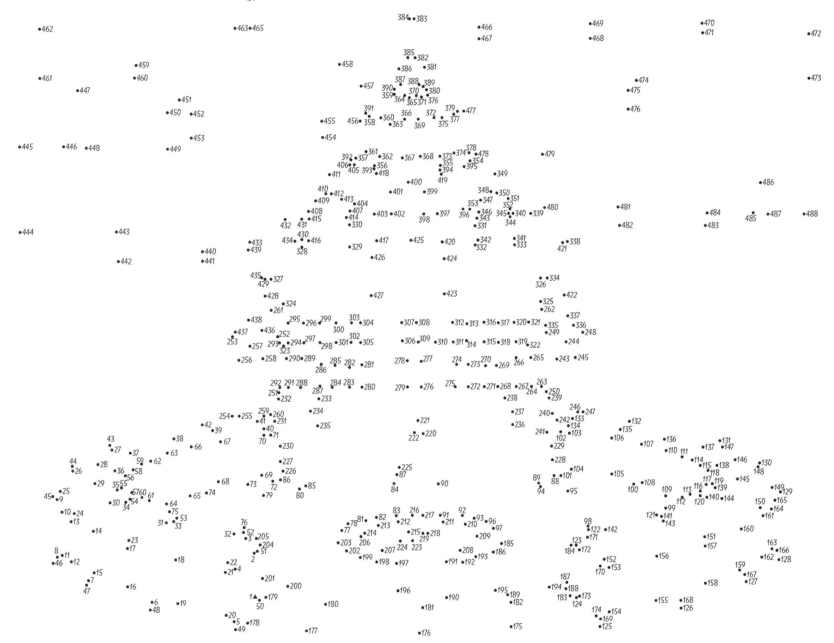

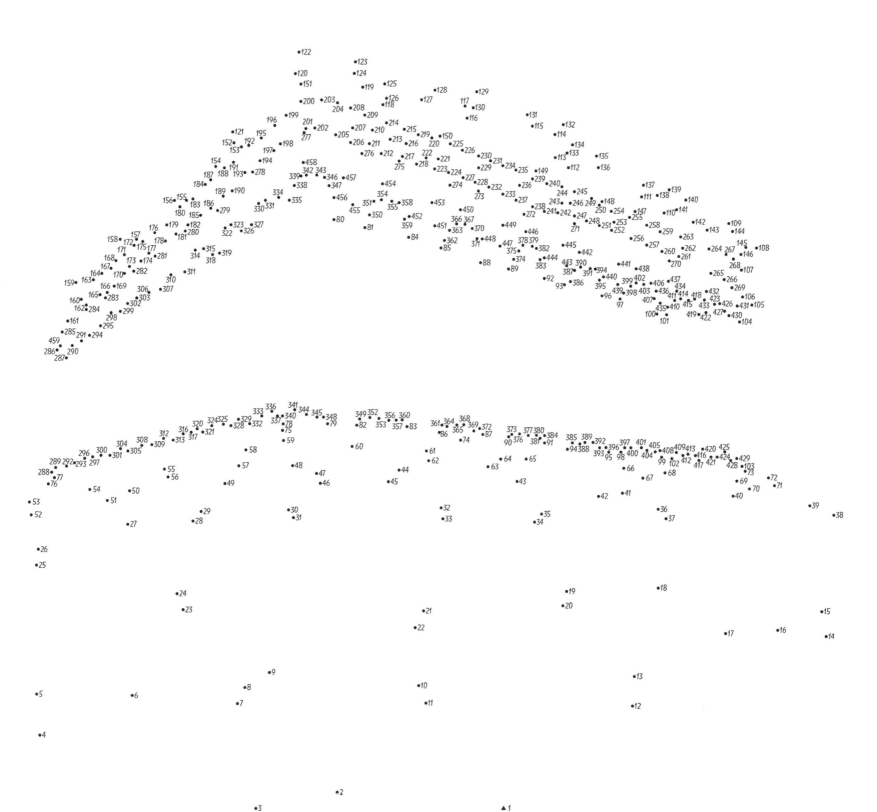

YOU HAVE BEEN
DRAWING

1. The Leaning Tower of Pisa, Italy
2. Taj Mahal, India
3. Sydney Harbour Bridge, Australia
4. Florence, Italy
5. Mount Rushmore, USA
6. Sanctuary of Truth, Thailand
7. Barcelona's Sagrada Familia, Spain
8. New York, USA
9. St Basil's Cathedral, Russia
10. Temple Mount, Israel
11. Hong Kong, China
12. Sydney Opera House, Australia
13. Golden Gate Bridge, USA
14. Petra, Jordan
15. Kinkau-Ji, Japan
16. Brandenburg Gate, Germany
17. Big Ben, England
18. The Forbidden City, China
19. Alhambra Palace, Spain
20. Ponte Vecchio, Italy
21. Arc de Triomphe, France
22. Dubai, United Arab Emirates
23. The Great Buddha, Japan
24. Statue of Liberty, New York
25. Pyramids, Egypt
26. Shanghai, China
27. London, England
28. Venice, Italy
29. Guggenheim Museum, New York
30. Hagia Sophia, Turkey
31. Kuala Lumpur, Malaysia
32. Christ the Redeemer, Brazil
33. Eiffel Tower, France
34. Great Wall, China
35. Neuschwanstein Castle, Bavaria
36. Kinderdijk Windmills, Holland
37. Coliseum, Italy
38. Yellow Crane Tower, China
39. Brooklyn Bridge, USA
40. Chichen Itza, Mexico
41. Tower Bridge, England
42. Rialto Bridge, Italy
43. St Peter's Basilica, Vatican City
44. Acropolis, Greece

●●●